Poem by
STING

Shape of My Heart

Art by
PICASSO

Edited by Linda Sunshine and Designed by Mary Tiegreen

Welcome

NEW YORK

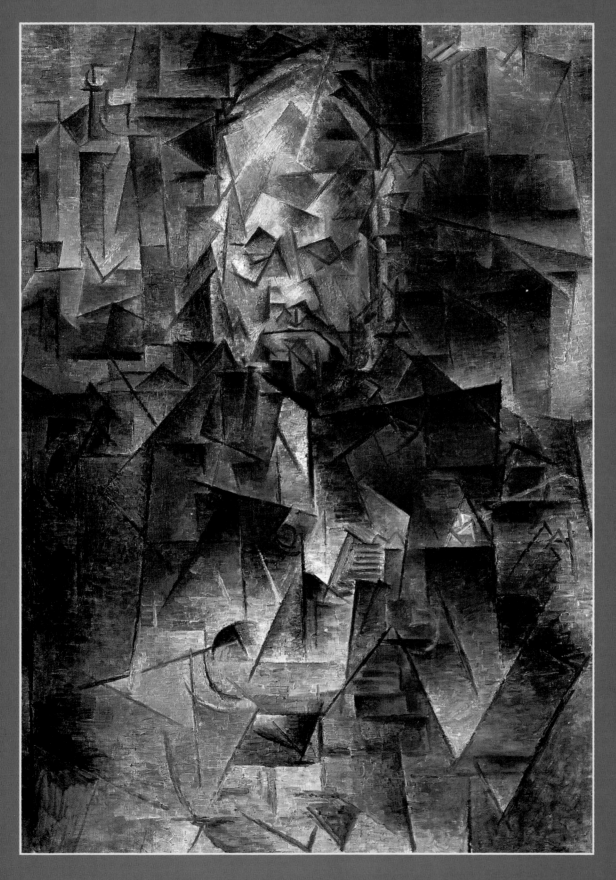

He deals
the cards
as a
meditation

And those
he plays
never
suspect

He doesn't play for

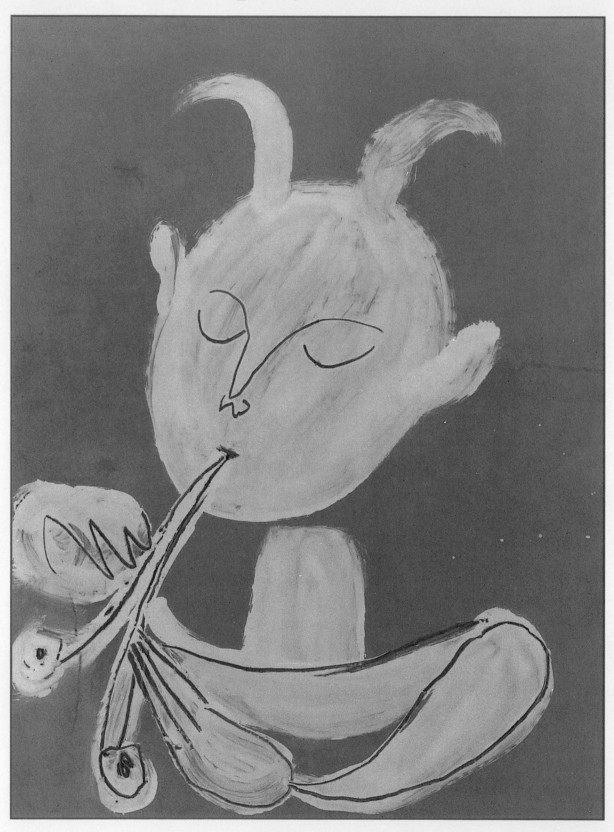

the money he wins

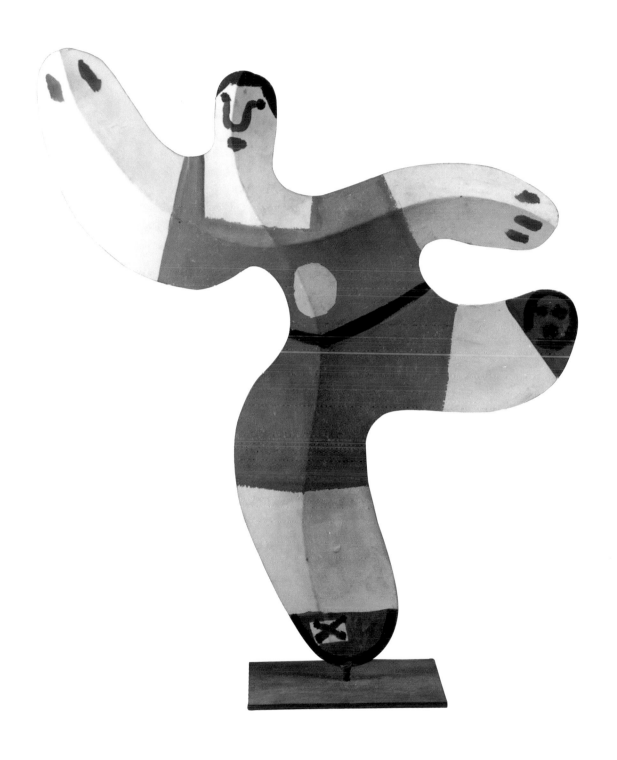

He doesn't play for respect

He deals the cards to find the answer

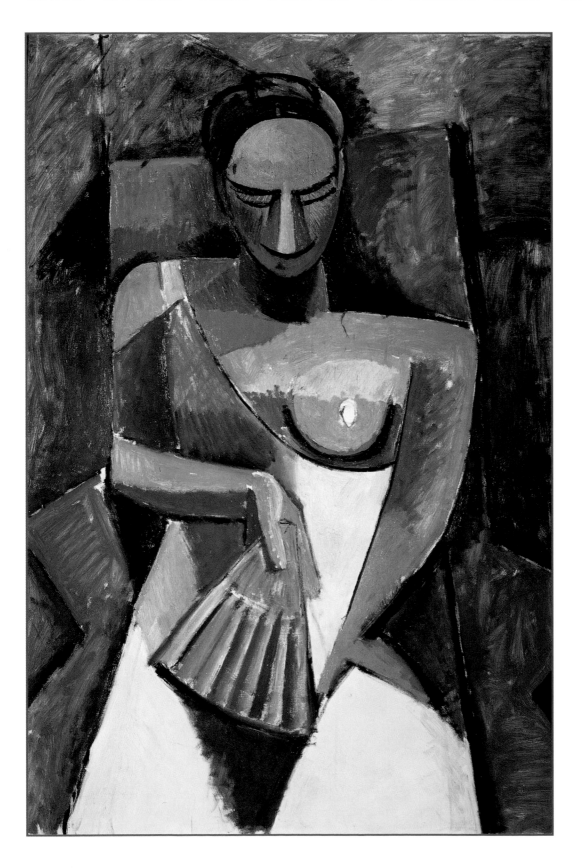

The
sacred
geometry
of chance

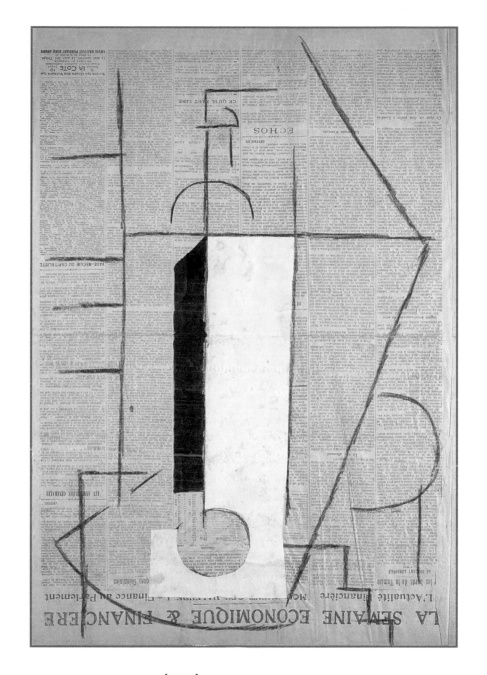

The hidden law
of a probable
outcome

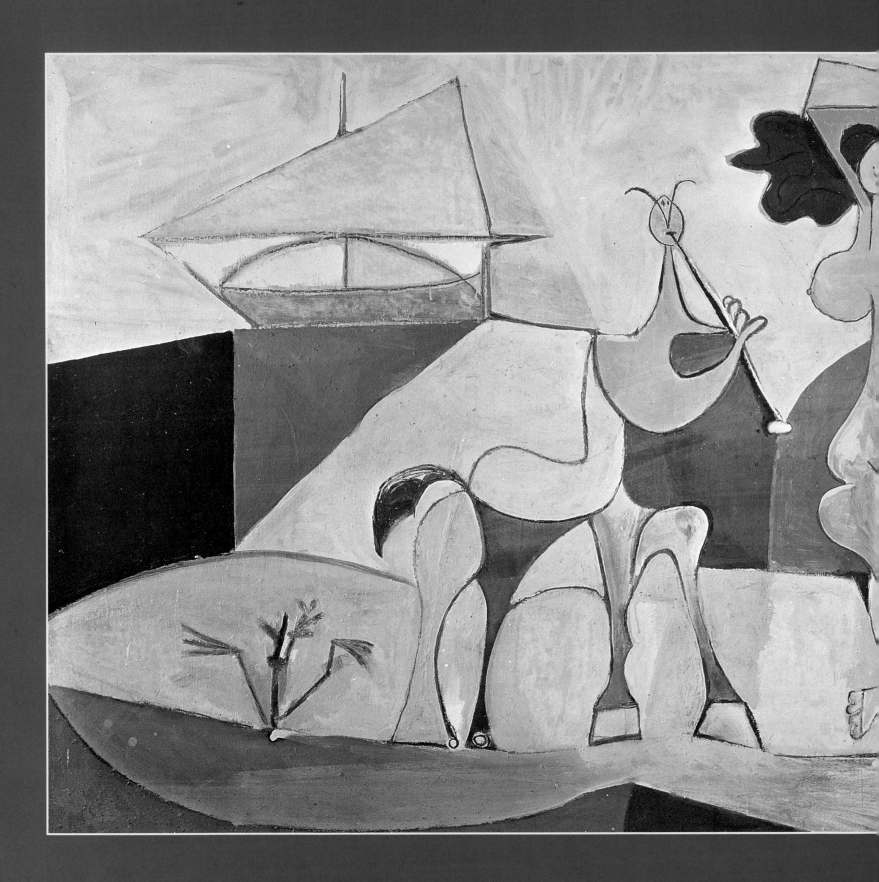

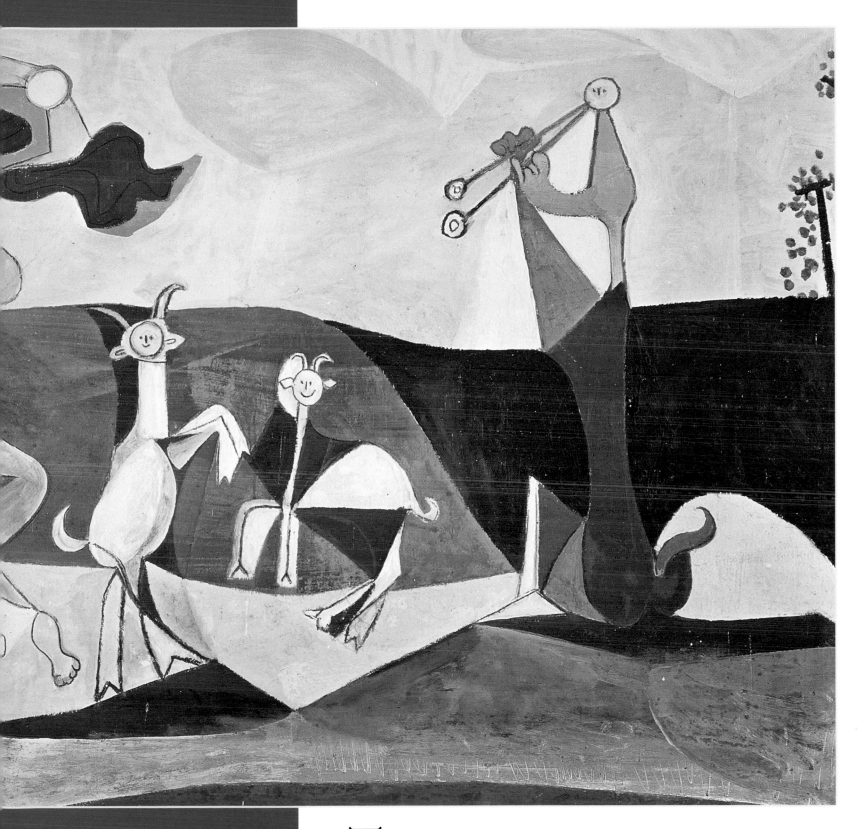

The numbers lead a dance

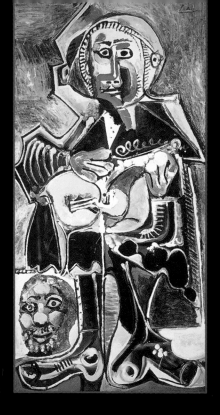

I know that the spades are
swords of a soldier

I know that the clubs are
weapons of war

I know that diamonds mean
money for this art

But that's
not the
shape of my
heart

He may conceal
a king in his hand

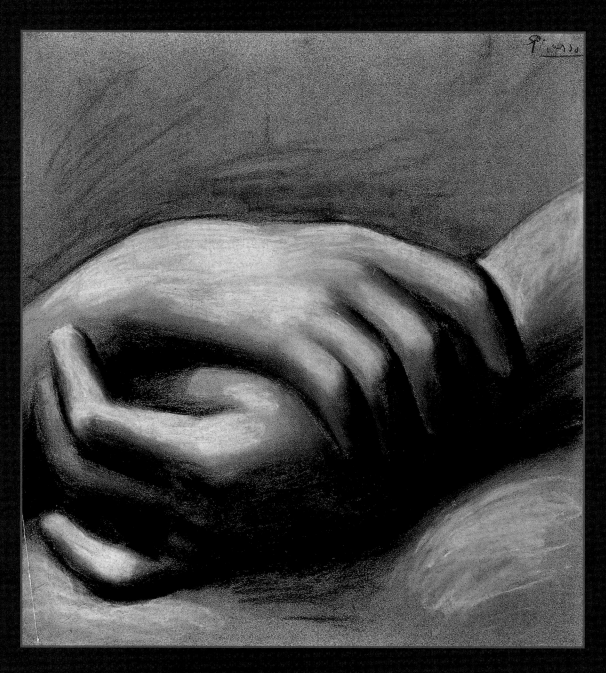

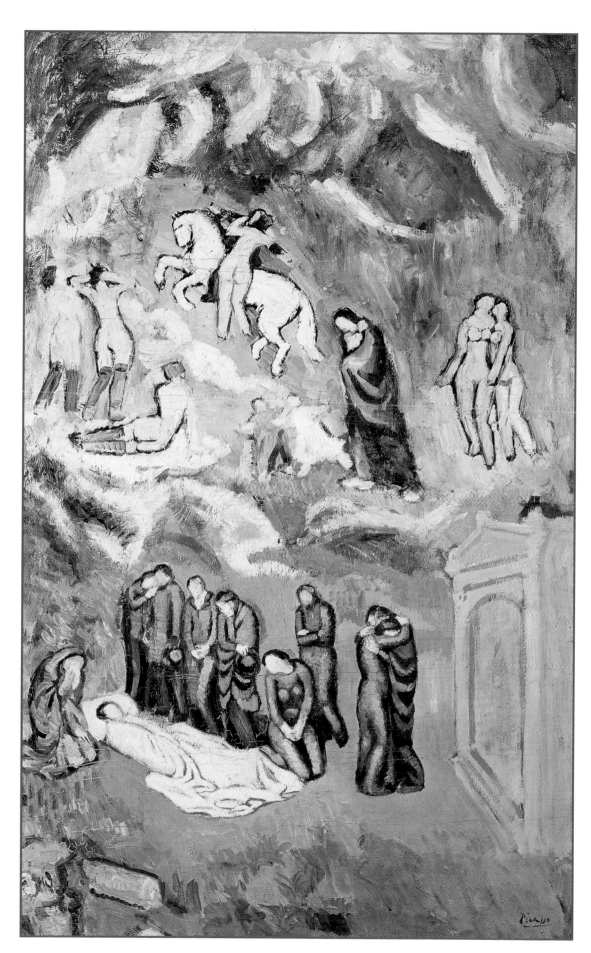

While the
memory
of it
fades

I know that the spades are
swords of a soldier

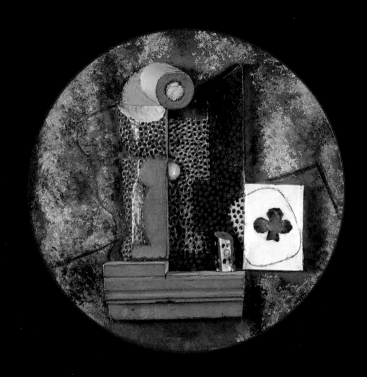

I know that the clubs are
weapons of war

I know that diamonds mean
money for this art

But that's
not the
shape of my
heart

And if
I told
you
that I
loved
you

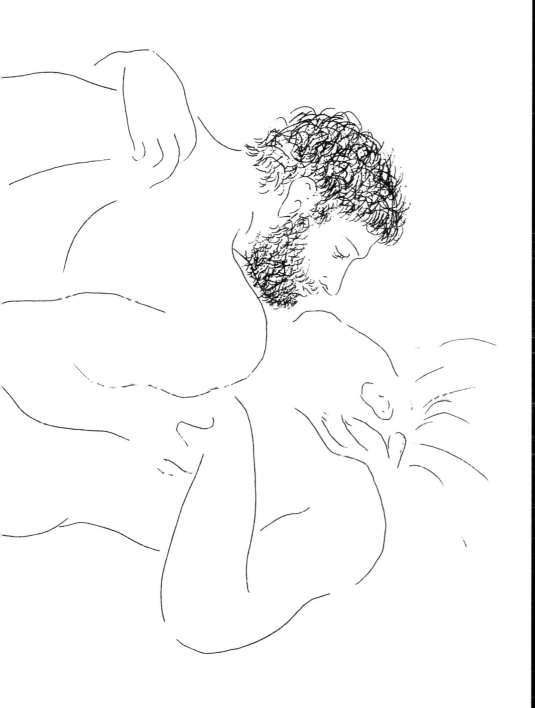

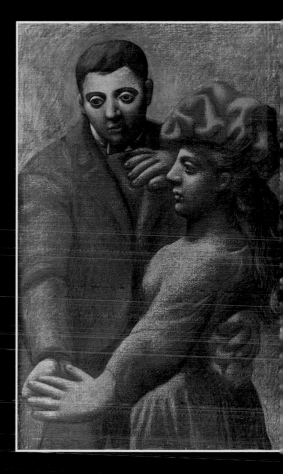

You'd maybe think there's something wrong

I'm not a man of too many faces

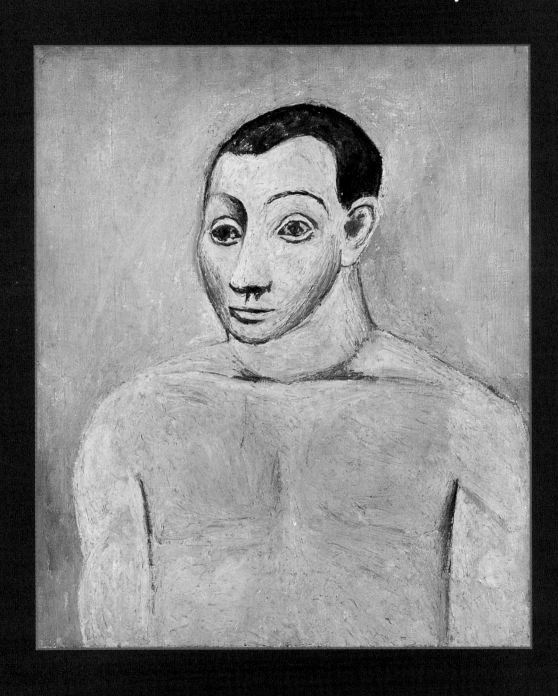

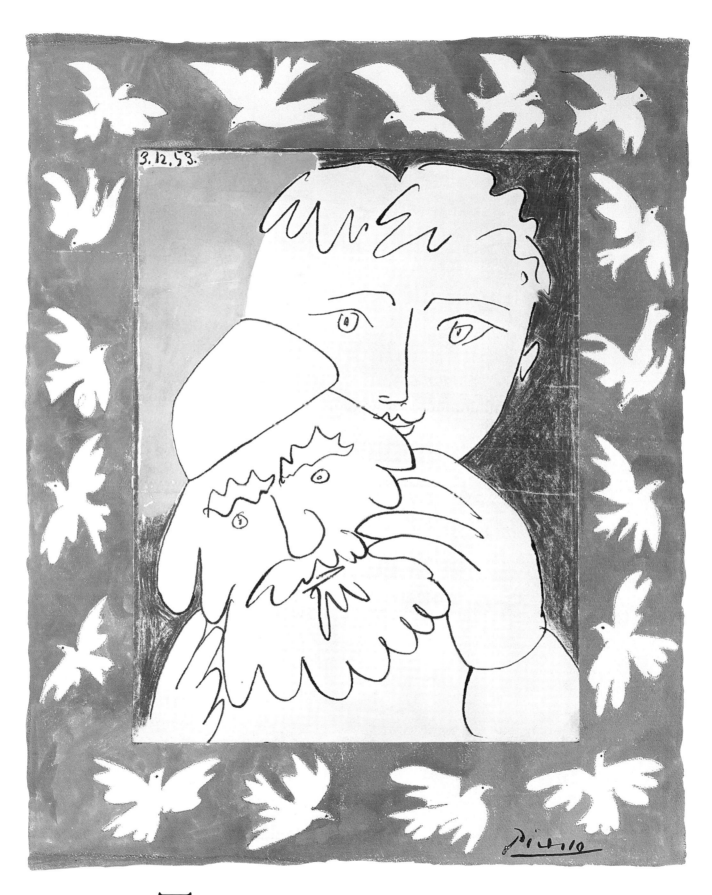

The mask I wear is one

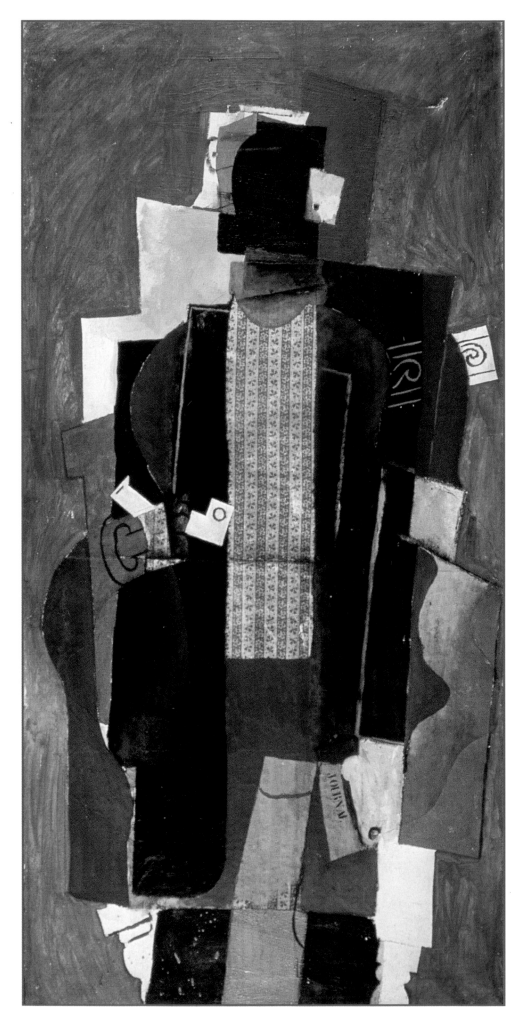

Those who
speak know
nothing

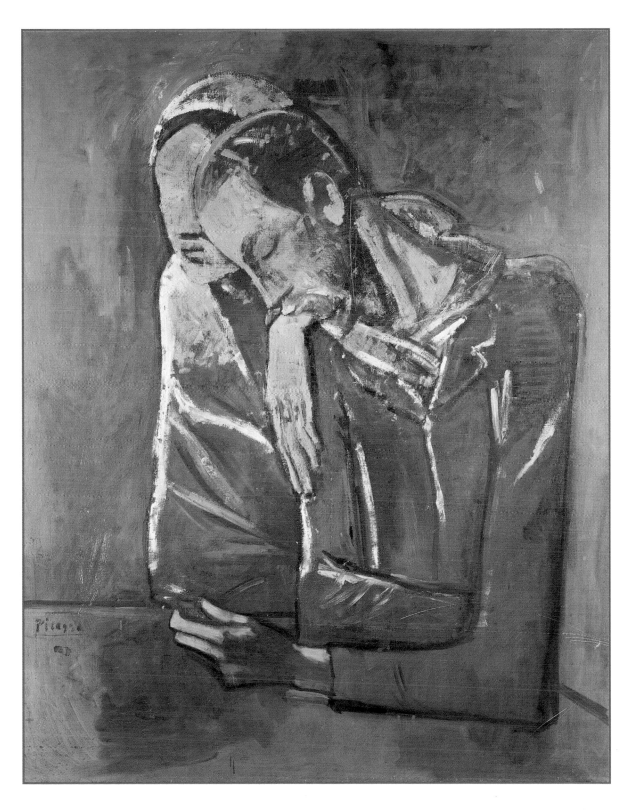

And find
out to
their cost

Like those
who curse
their luck in
too many
places

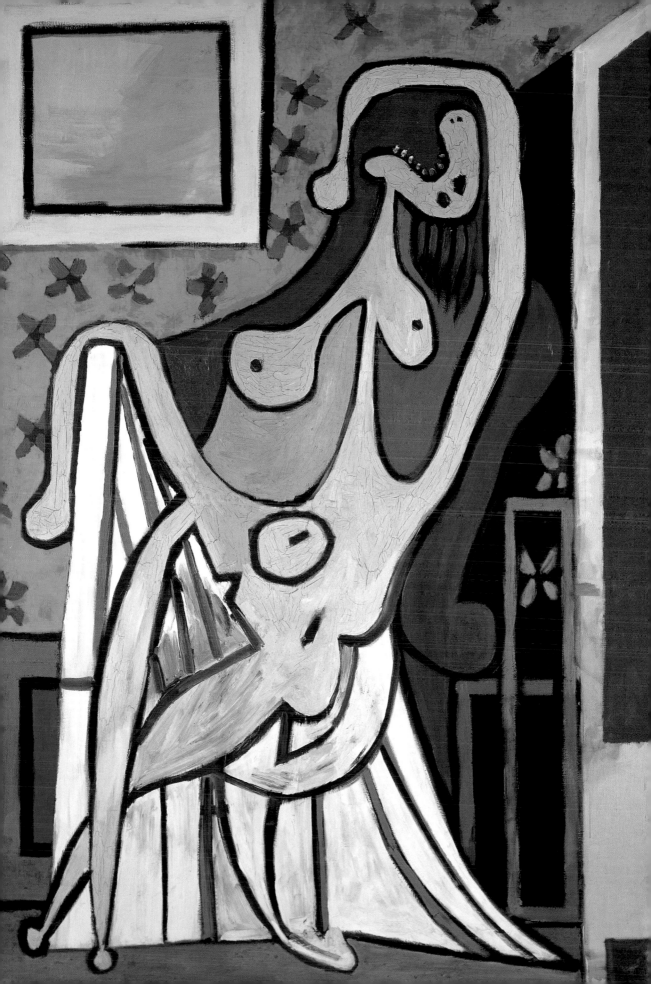

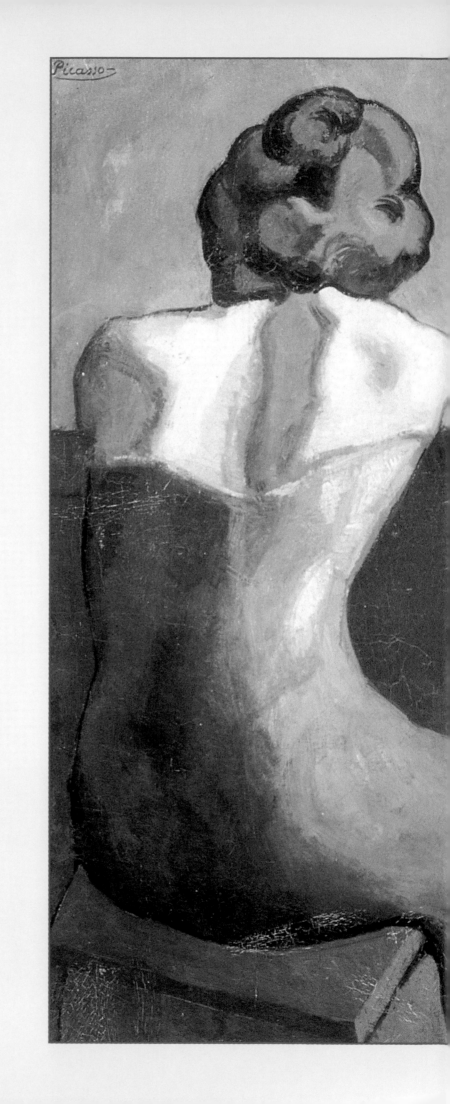

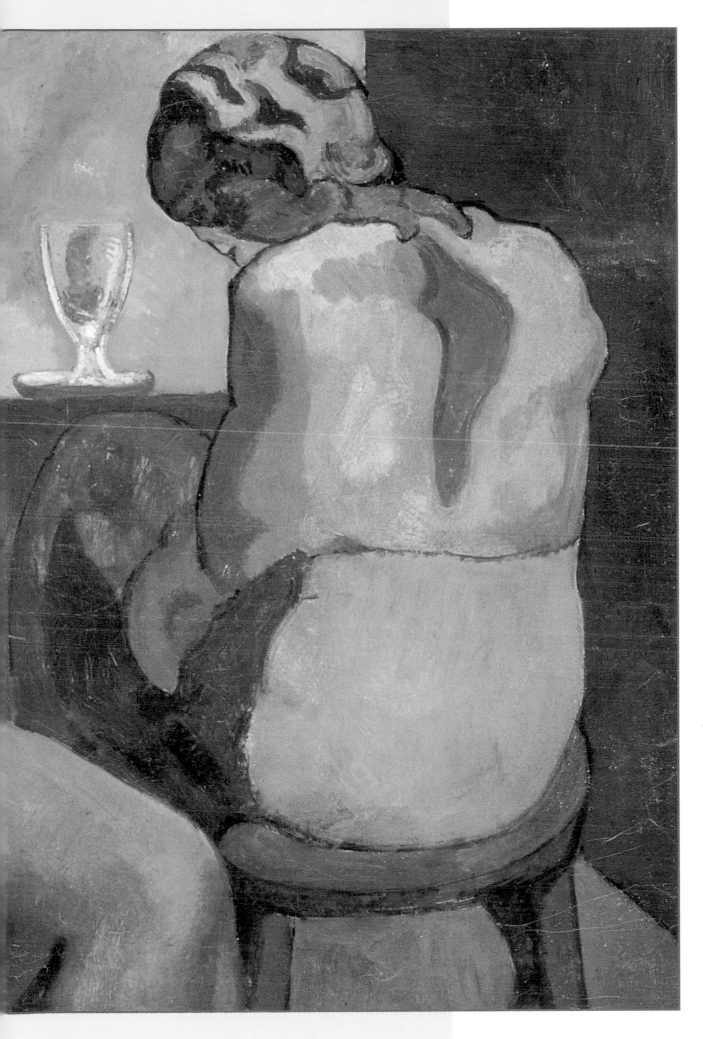

And
those
who
fear
are lost

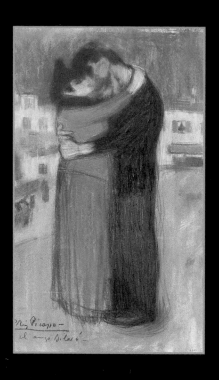

I know that the spades are swords of a soldier

I know that the clubs are weapons of war

I know that diamonds mean money for this art

Bᴜt that's not the shape of my heart

STING

A milkman's son, Gordon Sumner was born on October 2, 1951, in Northumberland, a working-class district of Newcastle-upon-Tyne, England. The oldest of four children, he worked as a school teacher and soccer coach by day while playing in various bands at night. He has used the name Sting since he was an eighteen-year-old bass player and was given the nickname because of a striped soccer shirt he often wore that supposedly made him look like a bee.

After seeing him perform with a band called Last Exit, Stewart Copeland invited Sting to join The Police in the late 1970s. With Sting as their lead singer, The Police debuted in 1978 with their album *Outlandos D'Amour*. The group had a unique mixture of reggae aesthetics and rock-and-roll rhythms and is now considered one of the world's most successful post-punk rock bands. Their catalog of eight extraordinary albums is a benchmark of innovation and has sold more than 40 million records. "Every Breath You Take," The Police's 1986 single, became a hit from the moment it first aired and remains a landmark in the annals of popular music.

The band broke up in the late 1980s. Since then, Sting has had an enormously successful solo career. From *Dream of the Blue Turtles*, released in 1985, to his most recent *Mercury Falling* in 1996, Sting's albums have provided music that satisfies both the heart and soul. "I like to write music as puzzles," says Sting. "I like to enfold as many levels as possible into a song." All of Sting's songs are multi-layered and complex; his lyrics represent a poetic vision that transcends time and place.

Sting is also an accomplished actor and has appeared in more than a dozen movies, including *Quadrophenia* (1979); *Dune* (1984); *The Adventures of Baron Munchausen* (1989); the English black comedy *The Grotesque*, which was released in the U.S. as *Gentlemen Don't Eat Poets*; and *Lock, Stock & Two Smoking Bells*, a movie directed by Guy Ritchie. On Broadway, Sting starred in Brecht and Weill's *Three Penny Opera* and has even forayed into classical music duets with Pavarotti and a role in Stravinsky's *The Soldier's Tale*.

"I like to put myself in all kinds of situations," Sting once said. "I'm never afraid to be a beginner." Indeed, this fearless pursuit of the new and original has informed all of his recent work. An update of "Every Breath You Take" called "I'll Be Missing You" was recently released by hip-hop artist Sean "Puffy" Combs as a tribute to murdered rapper The Notorious BIG. The song has sold more than seven million records around the world and topped the charts in fifteen countries. Sting and Puff Daddy sang the song together for the first time at the MTV Awards in 1998.

From punk to rap, Sting has shown an amazing ability to grow and change. In service to his highly individual voice, Sting's music incorporates jazz and classical strains, reggae motifs, folk themes, world-beat rhythms, and even country. Consequently, his music has always defied categorization. "I'm still a student," he insists. "I haven't carved myself a niche; I'm not smugly sitting. I'm constantly looking for other areas to try to excel in." He recently completed writing the music and lyrics for Disney's forthcoming animated feature film, *Kingdom of the Sun,* as well as an original song for Don Henley's album to benefit Walden Pond.

A musician, actor, and activist, Sting has received numerous awards for musical excellence, including four Brit Awards and a dozen Grammys.

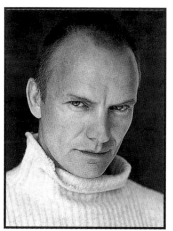

And inside every turning leaf
Is the pattern of an older tree
The shape of our future
The shape of all our history

—I Was Brought to My Senses

Sting has been married twice and is the father of six children. He lives with his wife, Trudie Styler, and their four children in a sixteenth-century Wiltshire estate outside of London. The stone manor, called Lake House, is in a setting that Sting claims, "Wordsworth would've found inspiring." Many of Sting's songs are composed on long walks in the woods around his home. "I find that the rhythm of going on long walks will suggest melodies," he has said. There is a recording studio on the estate where *Ten Summoner's Tales* and *Mercury Falling* were recorded. Sting also owns a house in London, an apartment in New York that formerly belonged to Billy Joel, a home in California, and a villa in Italy.

Throughout his career, Sting's social conscience has remained as expansive as his creative consciousness. A political activist, he has starred in Live Aid and championed the cause of Amnesty International. Along with his wife Trudie and a Brazilian Indian chief, Sting founded the Rainforest Foundation in 1989. He and Trudie have continued to be active in their commitment to stop the destruction of rain forests in South America and other places around the world.

Throughout his extraordinary career, Sting has consistently shown a generous, empathetic range of vision. The lyrics of his amazing song "Shape of My Heart" echo the feelings of an entire generation. Here is a true love song for the 1990s, full of ambiguities, self-doubt, hope, and mysticism. In Sting's vision, we discover that the truth of the heart is often masked by forces beyond our control.

Sting claims that the source of his vision has remained constant. "Music has healed my life in so many ways," he says. "Truly, I have been healed, in a sort of religious way, by the spirit of music."

The healing grace of music is not only evident in all of Sting's songs, it is one of his many gifts to the world.

PICASSO

Pablo Ruiz Picasso was born on October 25, 1881, in a big white house in Málaga, in the Andalusian region of southern Spain. His father, José Ruiz Blasco, was an art teacher and painter, and almost before the child could speak, he was drawing on his father's canvases. He studied in Barcelona and Madrid, though by sixteen he'd learned all that could be taught. He preferred drawing from life and sketched members of his family and his relatives in Barcelona; bullfights were an early inspiration and became a lifelong passion. In February of 1900 he had his first exhibit in a tavern called Els Quatre Gats (The Four Cats), where his 150 drawings, mostly sketches, were pinned to the smoky walls.

In October 1900, he left Spain for France. Though he did not speak a word of French, he was enchanted by Paris, especially its art museums. In 1904 he settled there permanently. For two years, he lived in poverty, but his work began selling in 1906, after he became friends with Gertrude Stein, Vollard, and Matisse.

In 1907, with the support of his friend Georges Braque, Picasso embarked on a series of formal researches that were inspired by Cézanne and African carvings. The result was Cubism, perhaps the most influential and far-reaching of all modern art movements.

His first exhibition in the U.S. was in 1911. The following year he fell in love with Marcelle Humbert, whom he called Eva to show the world that she was the first among women. "I love her and I write it on my paintings," he wrote in a letter. Indeed, "I love Eva" is written on many of his Cubist paintings from this era. Picasso was devastated when Eva died of tuberculosis in 1915. For the rest of his life, his work would be greatly influenced by the women he loved, most of whom he painted.

In 1917, he traveled to Rome to design sets and costumes for Cocteau's ballet *Parade*. Once there he gained access to Russian ballet circles and met Olga Koklova, a dancer with Diaghilev's company, who became his favorite model and, in 1918, the first Madame Picasso. She gave birth to their son, Paulo, in 1921. By now quite successful financially, Picasso painted many loving family portraits of Olga and Paulo.

In June of 1925, he shocked the world with *The Dance*, a vision of dislocated bodies painted in vivid colors that flabbergasted critics and revolutionized painting. The controversial picture, heralding the beginnings of surrealism, reflected the dislocation of his marriage to Olga after he started painting Marie-Thérèse Walter in January of 1927. She was seventeen when they met (he was forty-six), and he kept their love affair a secret for as long as he could, although he

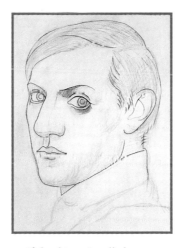

If the things I really love—
water, the sun, love—
could be bought,
I'd have been ruined long ago.

could not resist writing her initials at every opportunity. In the next decade, he would paint her face and form innumerable times. In 1935, Marie-Thérèse gave birth to a daughter, Maia, named after Picasso's young sister who'd died as a child.

In 1936, Picasso met Dora Maar, who soon became his new model and mistress. After the outbreak of the Spanish Civil War, they moved into a studio together. Dora Maar was an elegant, dark-haired beauty with sharp features and long hands, and the portraits Picasso painted of her are among his most significant works of 1938.

Picasso's postwar period was marked by portraits of Françoise Gilot, a young painter Picasso met in 1943. Gilot's oval face, aquiline nose, almond eyes, intense stare, and curling hair would be re-created in numerous portraits. They had two children: Claude in 1947 and, two years later, Paloma, whose name means "dove" in Spanish. The same year, Picasso's drawing, *The Dove*, was chosen as the symbol of the 1962 National Peace Congress.

Though he was nearly seventy when his last two children were born, he was very much involved in their early life. They lived in La Galloise, a villa near Vallauris, and spent time on the beach together. Here Picasso became involved with ceramics. It was soon difficult to maintain their privacy as word spread that the Picassos could be seen every morning at a certain beach on the Côte d'Azur, where a crowd gathered daily to see them.

Their idyllic life on the beach ended when Françoise and Picasso separated in 1953. In 1961, she would write about their relationship in her memoirs, *Life with Picasso*.

By 1955, Picasso was being followed constantly as if he were a movie star. The attention was overwhelming. For privacy, he moved to La Californie, a turn-of-the-century villa situated above the hills on the Riviera. He was now living with Jacqueline Roque, the beloved model whose presence would henceforth dominate his work. They married in 1961, and the following year Picasso produced seventy Jacqueline paintings, drawings, engravings, and ceramic tiles. He celebrated his eighty-fifth birthday in 1966 with a worldwide celebration and a major retrospective in Paris.

So many of Picasso's greatest works were informed by the women he loved. He painted women unlike anyone had before or would after him. In the process, he made the world see itself in a different light, and the world has changed because of his vision. "Painting is stronger than I am," he once said. "It makes me do what it wants."

Pablo Picasso died on April 8, 1973, at Mougins, at the age of ninety-one.